NANCY GONZALEZ

COLOMBIA NEW YORK

W0010937

Endpapers: Library of colorful crocodile clutches. © Anita Calero.
Page 5: Portrait of Nancy Gonzalez. © Gilles Bensimon.

© 2013 Assouline Publishing
601 West 26th Street, 18th floor
New York, NY 10001, USA
Tel.: 212-989-6769 Fax: 212-647-0005
www.assouline.com
Printed in China.
ISBN: 9781614281115

PAMELA GOLBIN

ASSOULINE

"Fashion is a passing thing … elegance is innate."
—*Diana Vreeland*

I don't remember when I first met Nancy Gonzalez—it was one of those encounters, like meeting a long-lost friend. She embodies the archetypal South American woman, exuding inner strength, audacious conviction, and true elegance. Nancy's small and deceptively fragile frame conceals a powerful will, but it is her irresistible laugh and joie de vivre that reveal a profoundly generous and luxuriant nature.

Nancy Gonzalez is a passionate ambassador not only for her native Colombia but also for the distinctive cultural heritage of her people. Fame and fortune have never been her driving forces. Her quest is a much more personal one, in which happiness, respect for others, and a yearning for knowledge are constant principles.

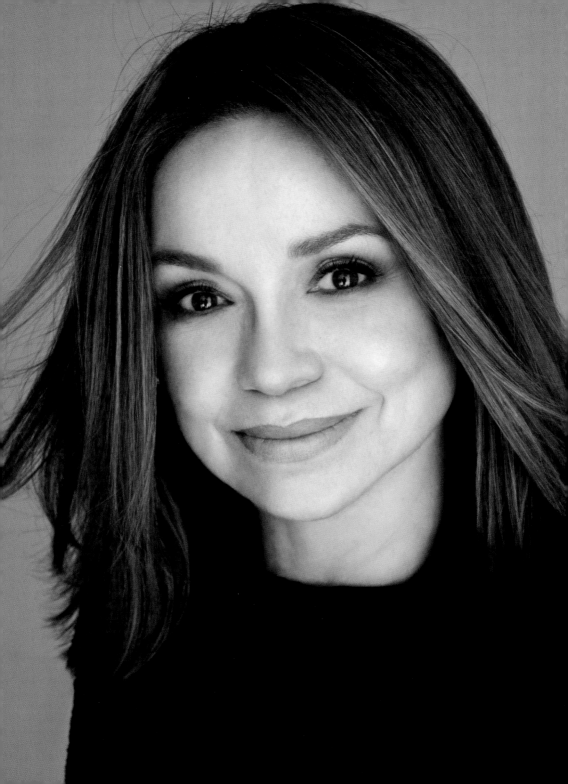

Nancy's vision is all about the intangibles—personal growth, tolerance, patience, and the pursuit of excellence. Joy, surprise, and optimism are her blueprints for life. The embodiment of these ideals took form in a most unexpected way: Over the course of two decades, she has become a world-renowned accessories designer.

"A handbag," she says, "is a hint of who you are and what you value, a reflection of personal style." Her creations represent a longstanding collaboration with both her artisans and her clients; she is ever attentive to their desires and opinions. The pleasure of choice is only one of her many gifts to the seekers of today's real luxury.

"I believe the highest form of luxury is having options," she says, adding that her favorite indulgence is "freedom."

"The Nancy Gonzalez brand tells the story of a people, their integrity, and their values."

Nancy's own fashion career began quite innocently in 1988. "I was looking for something that came from inside, that made me feel complete, something in which I could explore and develop my personal skills and at the same time express my creativity." Gonzalez could have very easily joined her friends at the country club, but at thirty, as a young mother of two, she made the courageous decision—particularly brave for a Latin woman—to start her own business. She was known for her elegance, and her friends encouraged her to do something in the realm of fashion. She had always loved belts and had an extensive personal collection, so she intuitively began designing them using precious skins. "I

wanted the best possible material, and in Colombia the finest was crocodile," she explains. What today seems like a clever strategy was by no means calculated. "Nothing was ever planned. The company grew organically because my clients wanted bags to go with their belts."

Beginning with just a single sewing machine and one *zapatero*, or cobbler, Nancy discreetly produced a range of designs from a small room in her mother's Cali home. Soon her first label, Encueros de Colombia, had seven boutiques in the country's most fashionable locations. The luxurious belts and assorted handbags drew on Colombia's natural resources and showcased its traditional craft skills. They were quickly discovered and eagerly acquired by elite, urbane Colombian women, who admired their quiet elegance, exceptional quality, and unique designs. "My clients traveled quite a bit, and by 1998, I was receiving phone calls from all over the world asking me if I would sell my designs," she recalls. "Then one of my friends suggested that I should sell in New York."

"Bergdorf Goodman was my favorite store in the city. During one of my trips, I had the chance to meet with them, and I presented the only two purses that I had with me. They were looking for new handbag designers to promote, and they asked how long it would take to deliver a collection. I replied, without flinching, 'Fifteen days.' When I have an idea, I'm unstoppable. So in just a fortnight, I delivered a collection of eight crocodile handbags in five colors: black, coffee, brown, dark red, and dark green." The Nancy Gonzalez brand was born. "I never would have had the idea of signing my own creations. It was the team at Bergdorf Goodman that convinced me to use my name. I remain grateful to them for their guidance throughout the beginning of this adventure."

During this formative period, she closed her retail operation in Colombia and decided to solely concentrate on the international market.

"Fashion should be something that amplifies, and does not alter, who you are."

The biggest challenge of designing handbags is achieving the perfect balance between function and creativity. Nancy's philosophy of good design is that it should be anchored in the fundamental virtues of quality, craftsmanship, and value. The trick, she reveals, "is to achieve all of these attributes at once. Purity, balance, rigor, and composition are the aesthetic pillars of my brand. Dignity, optimism, and structure are its essence. It is an aesthetic brought together through affection more than taste or culture. Every woman needs a handbag, but we also want a pleasing experience— something to make us smile."

Her native Cali, the third-largest city in Colombia, serves as her guiding inspiration. "I love everything about Cali—its exuberance, its people, and of course, its colors. You only have to look at my handbags to see that." Her homeland's rich landscapes—the magnificent color palette of its luscious gardens, filled with rich vegetation, tree branches extravagantly decorated with wild orchids—are ever present in her work. "We have blue skies three hundred and sixty-five days a year, the largest number of bird species in the world, and an array of greens that is incredible. Even after all these years, nature is still my best collaborator—and life is my source of inspiration."

Nancy Gonzalez's design process is not a premeditated formula but rather an ongoing, passionate dialogue with the world that surrounds her. Several months of the year, she travels around the globe armed with a little camera, recording the visual inspirations that nourish her creativity. She composes an elaborate inspiration board, with her drawings and a collage of a million things that have caught her eye. But what most motivates Nancy is her clients. She doesn't have a particular woman in mind, but she is constantly asking herself, "Who is going to use this bag? I don't think of actresses but of my real clients, who I meet all year round at my personal appearances. They are the ones who encourage me to move forward."

As a dreamer anchored in reality, Nancy Gonzalez not only provides her company's creative force but also directs all facets of production and ferrets out new fabrication methods worldwide. "I love to make things happen," she says. "Once I have made a decision, it's very important for me to see it realized. I am fascinated by the organization and the logistics needed to make things work."

Her daily agenda is one of hands-on participation, ensuring that both production and distribution commitments are met on schedule. She is an impassioned motivator with a skilled design team, incorporating dedicated pattern makers, weavers, skin cutters, and machinists. Precious skins require extremely specialized technicians who can handle their challenging, irregular surfaces. Nancy nurtures these talents. Collaboration is crucial in the development of new designs, and her technicians actively participate in the development of the collections. Gonzalez regularly invites highly reputed artisans from Italy and France to enrich her employees'

knowledge of international methods and new techniques. "I've spent years figuring out which factory does a glossy finish the best and which one does natural or mother-of-pearl. I want my workers trained by the most skilled people in the world."

"Our bags are unique, as no skin is like any other."

Precious skins are like gems; each is nature's distinctive creation and must be cut and polished depending on its intrinsic form. It is this collaboration with nature that both fuels Nancy Gonzalez's imagination and provides her biggest challenge. Not only do her chosen precious skins require extreme technical expertise to manipulate, each one also has its own distinct character. Whether they are the skins of crocodiles, alligators, lizards, or snakes, Nancy Gonzalez employs them in the most spectacular way—always with the utmost respect for the integrity of the material. "Two hides are never alike, so in a way, the skins tell me how they should be used," she says. "I feel very connected to them. I love the challenge of figuring out how to use them in the best possible way."

Only the highest-grade skins are accepted. They are always centered, in cut and in design, so as to maximize each one's beauty. Nature's infinite unpredictability offers the perfect source of ultimate luxury, that is, uniqueness. Skins are selected and matched by expert eyes, as it often takes several skins of complete tonal perfection to complete one handbag. Made by individuals for individuals, the designs are hand-sewn and individually hand-dyed. Every color comes in an

astonishing array of shades. Due to the properties of each particular precious skin, the dyeing process will never reproduce the same final hue. Thus, no bag is identical to any other. Confronted with a choice of ten black clutches, the Nancy Gonzalez client finds that no two are alike in texture or tone. Furthermore, every bag is lined in a different shade of suede, randomly chosen, making the final color combination a surprise, like a wonderful present. Nancy Gonzalez indulges each of her clients in nature's generous variety and the luxury of choice.

"We use colors as surprising neutrals."

It is difficult to imagine that just twenty years ago, "a crocodile bag was either brown, black, or cognac, a very expensive and very heavy status symbol that a mother or a grandmother would wear on a formal occasion. I wanted to propose a precious-skin bag at an approachable price with an accessible design that was colorful and light. It was no longer only about the skin but also about exploring new techniques of design."

Every year, Nancy Gonzalez introduces four hundred and fifty new styles, divided among three collections: Fall, Spring, and Resort. Two iconic bags—the clutch and the tote—are always available. All of the bags are offered in three hundred colors and finishes, with twenty to thirty new chromatic options added each season. From shocking fuchsia to electric blue, from vibrant yellow to tropical orange, the entire color spectrum is explored and represented. With laminated, polished, glossed, varnished, metallic, and numerous other

unexpected finishes, the Nancy Gonzalez catalog has grown to the size of a telephone book. Nothing is ever taken out, just added. Like a work in progress, the collection is permanent and ongoing but never complete.

"I identify with my customers and their needs, and that is why I like to provide such a palette of choices," she explains. The possibilities are limitless, creating almost a bespoke service in which each store's buyer develops a collection depending on clients' needs. Additionally, each handbag is produced in a limited edition of forty per style and color, which means that the same bag is rarely available in more than one place. While designers often have up to twenty points of distribution in one city alone, Nancy Gonzalez has made it a priority to be present in no more than two stores per city. This allows her to create a privileged relationship with and an exclusive experience for her customers. "We are better able to take care of the clients and to partner with them correctly. I want to hear what they have to say and to learn from them." As she constantly emphasizes, "We don't do business with companies but with people."

"Our artisans are the patient inventors of a new know-how."

To the eternal question "How long does it take to make a bag?" Nancy Gonzalez always replies, "It's not how long it takes to make the bag, but how long it takes to train someone to make the bag." Part of her implicit mission is to provide people with long-term vocations. "In Colombia, we did not have a history of crafting crocodile handbags, but we did have an extensive tradition of manual expertise. There is

such purity to pre-Columbian art, but also rigor. These are the same feelings I want to evoke as I challenge myself and our artists to use skins in new and unexpected ways."

Gonzalez's trainees begin by making small crocodile clutches before graduating to medium-size handbags. For clutches, the average training time is six months. A medium-size bag demands a team of three artisans and an average of twenty hours to complete. After an apprenticeship lasting at least seven years, a small fraction of the skilled workers possess the qualities needed to become master handbag makers. Like the intricate fabrications of an haute couture atelier, each piece bears proof of the hand-workmanship of the artisan who made it. That personal mark, like a signature, is such that every bag can be traced back to its origins.

By treating precious skins as though they were fabrics, Nancy has defied conventional limitations and surpassed all prior technical boundaries. Under her direction, skins have been quilted, pleated, ruched, slashed, braided, knotted, and laced, to name just a few of her innovative techniques. In addition, she has created hundreds of different weaves, inspired by the artistry of indigenous Colombian tribes. It is a remarkable achievement to transform a crocodile skin into "threads," but it is far from the final chapter in this journey of experimentation.

"I feel a tremendous responsibility for and commitment to both the people who work for me and my country."

As a business philosophy, Nancy Gonzalez has chosen to merge the artistic with the altruistic. Her Cali factory employs more

than four hundred artisans, 90 percent of whom are women. She seeks out single mothers for training and provides them with an on-site day care. "For me, if a mother has a job, then her child has a much better chance for a healthy life and a successful future." In South American culture, a woman entrepreneur is a rarity. Nancy Gonzalez is a leading public example of female accomplishment. "My way of helping the community is to provide work and self-esteem, encouraging women to accomplish their goals."

An ethical vision also pervades the methods by which she controls her manufacturing and supplies. When Gonzalez began, no one in the market was able to provide her with the volume and the quality of skins she needed. This led her to set up a vertically integrated artisan culture with in-house capabilities encompassing every aspect of the making of a bag. "The only way for us to be certain that the skins are the correct quality and that all the environmental requirements are met is by controlling the whole process. The crocodiles we use are farm-raised, and 25 percent of the animals remain on those farms in order to promote the sustainability of the species. Every bag is numbered and registered to track the origin of each skin." For Gonzalez, today's sustainable luxury was a necessity from the beginning, not a choice, and that has made her a leader in environmental issues in her field.

"We embrace the future."

In a high-tech world of smart materials, where cyberspace is the preferred domain, Nancy Gonzalez has found a perfect balance between new technological innovations and the

authentic handmade design that has propelled her name to success. With rare self-assurance in the ever-changing world of fashion, she has continued along her own path to create an authentic product for a real clientele.

In recognition of her talent, the Accessories Council recently honored Nancy Gonzalez with its prestigious Brand of the Year award. That recognition was significantly important for a brand that produces only one category of product, handbags. "It shows that you can be large, make volume, and be resonant in the industry even though you're not creating a lifestyle brand," she says. "It was an immense validation from my peers and a true honor to receive it on behalf of my employees and my country." Acknowledgment has also come from museums, such as the Metropolitan Museum of Art's Costume Institute, which have added her creations to their collections, underlining the importance of her work and its relevance in today's historical fashion context.

Nancy Gonzalez has defined luxury as a constant quest for quality and excellence. Her clients are at the heart of her brand. And happiness is at its origin. "Everyone needs joyful experiences. We are not only expressing our designs but also our values and our passion."

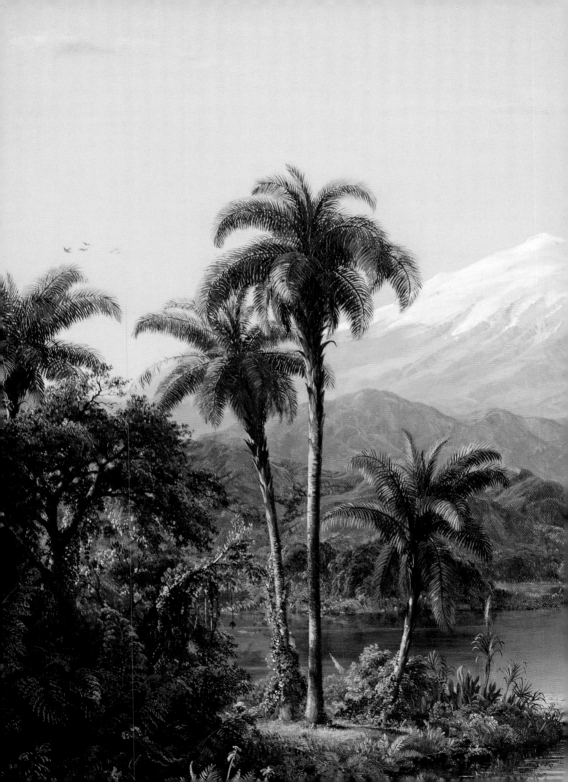

Exoticism:

I

The perception of the diverse.

II

*Everything that reroutes us
from the ordinary.*

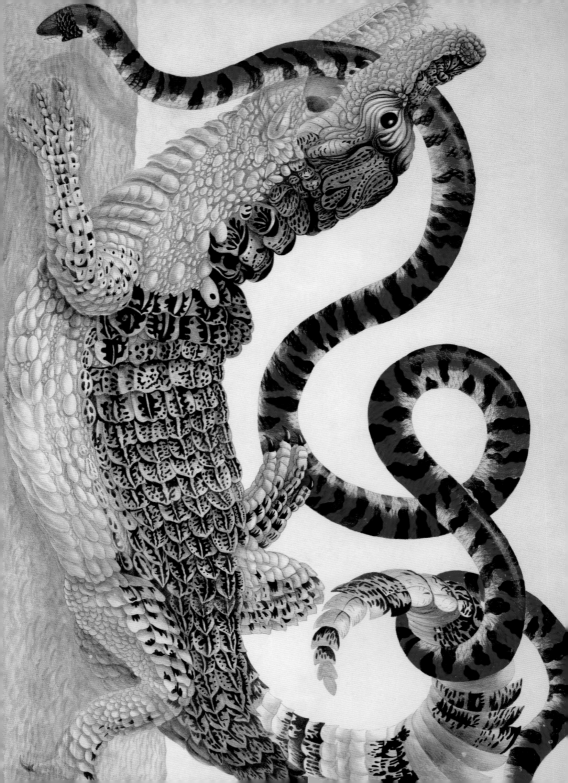

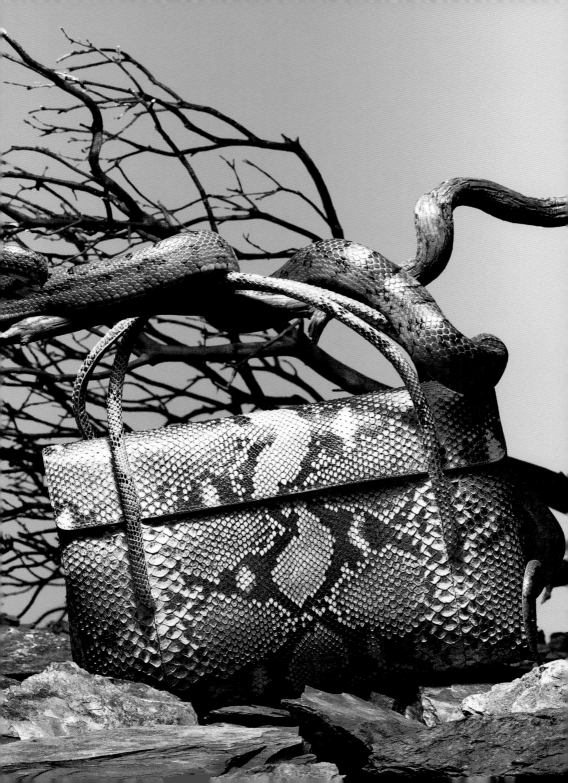

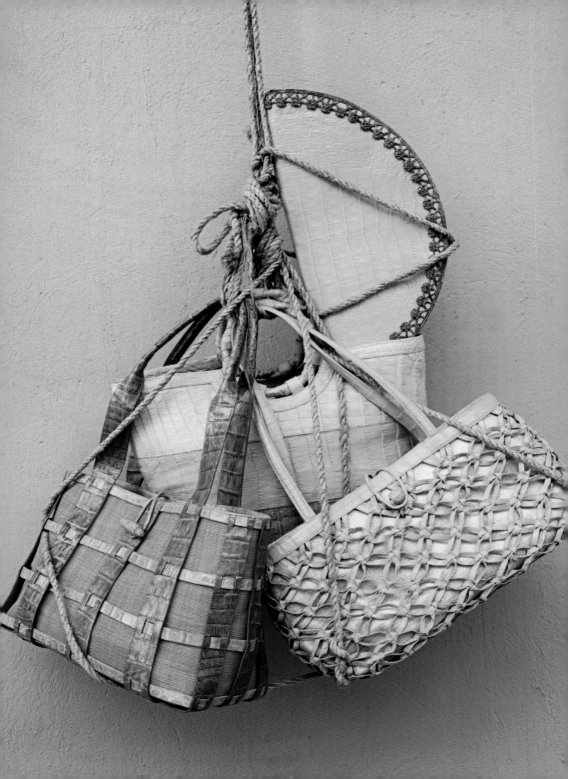

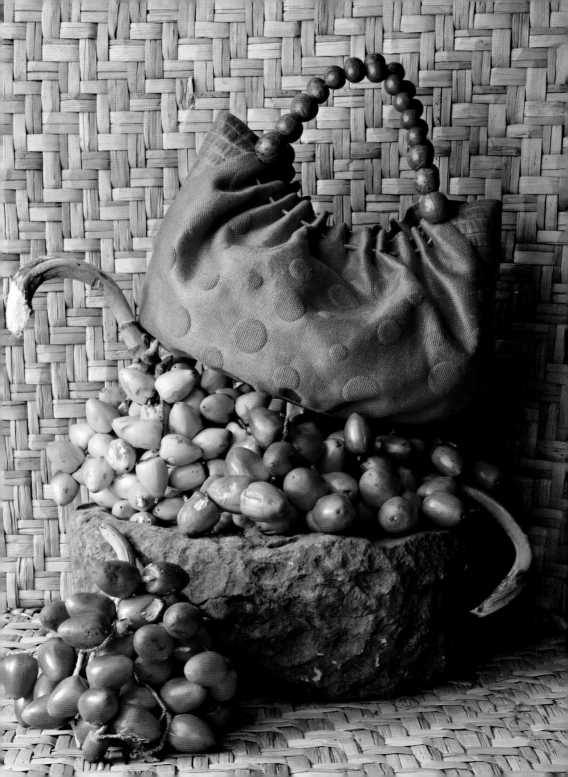

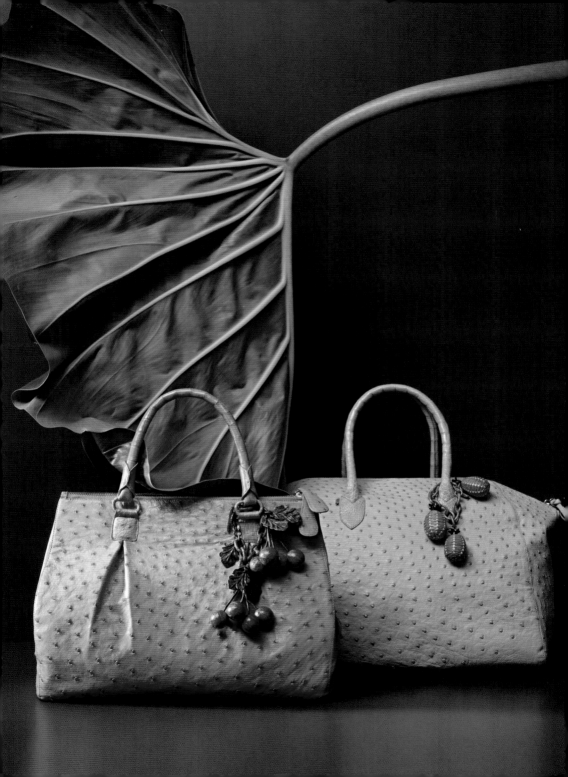

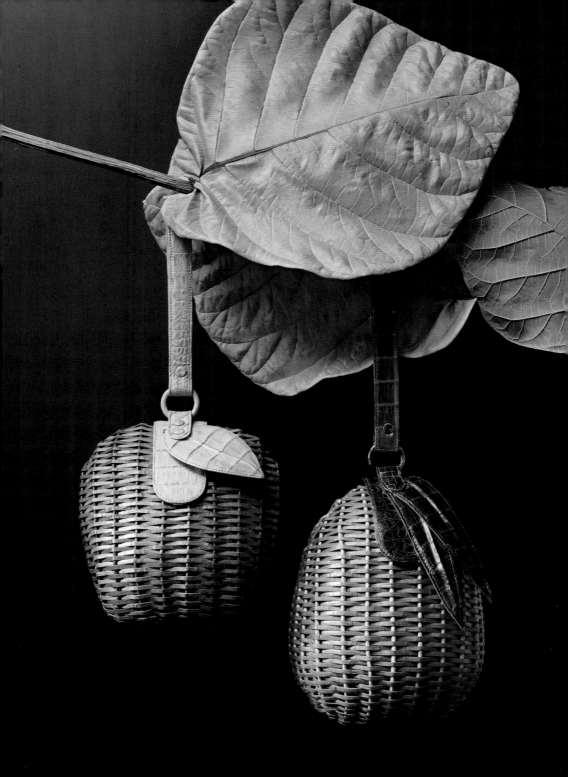

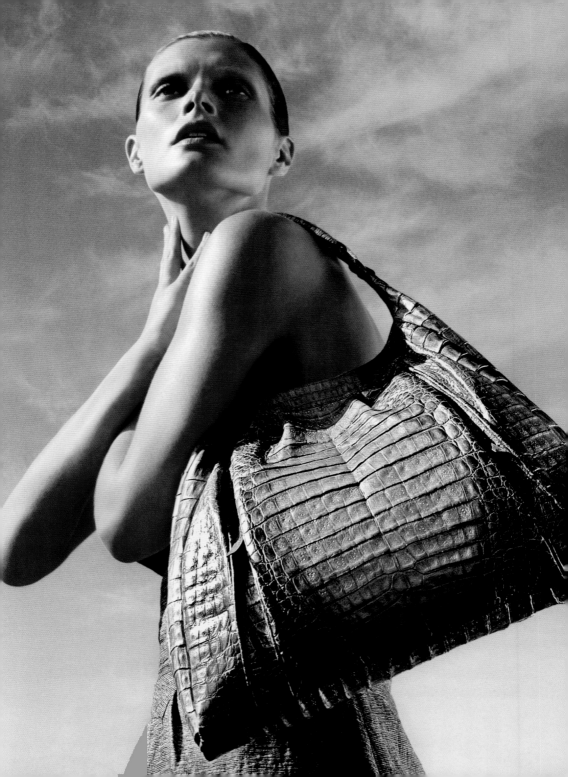

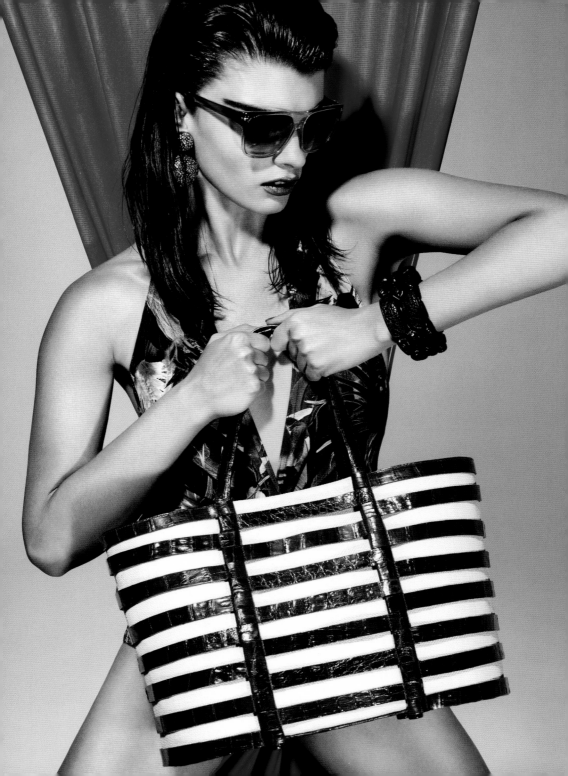

Unique:

I

Having no like or equal:
incomparable.

II

Limited in occurrence.

III

Not typical.

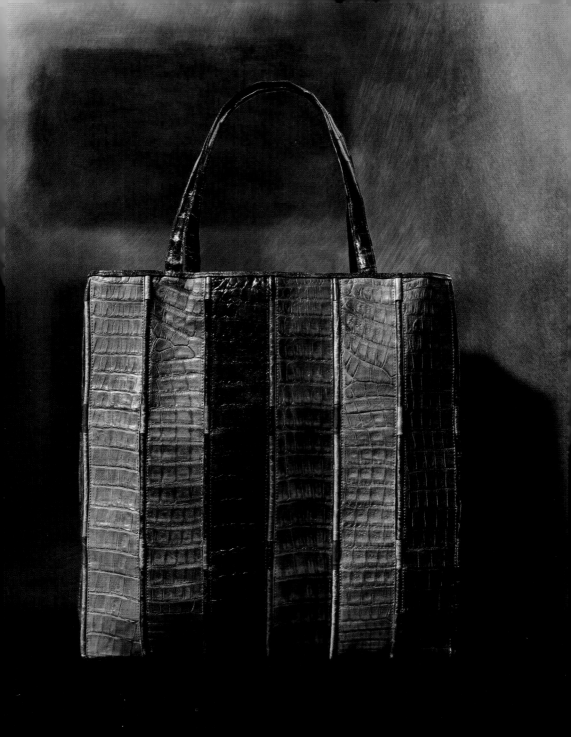

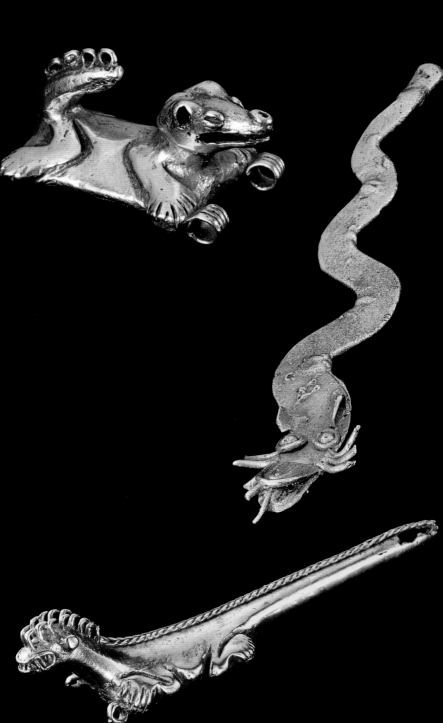

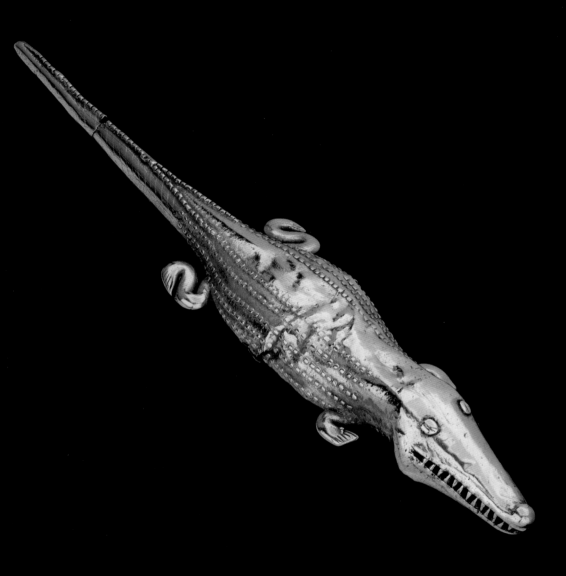

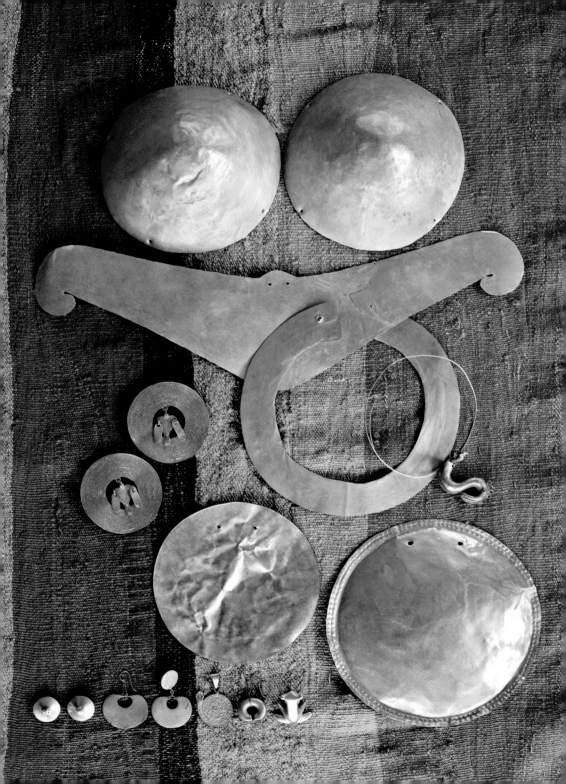

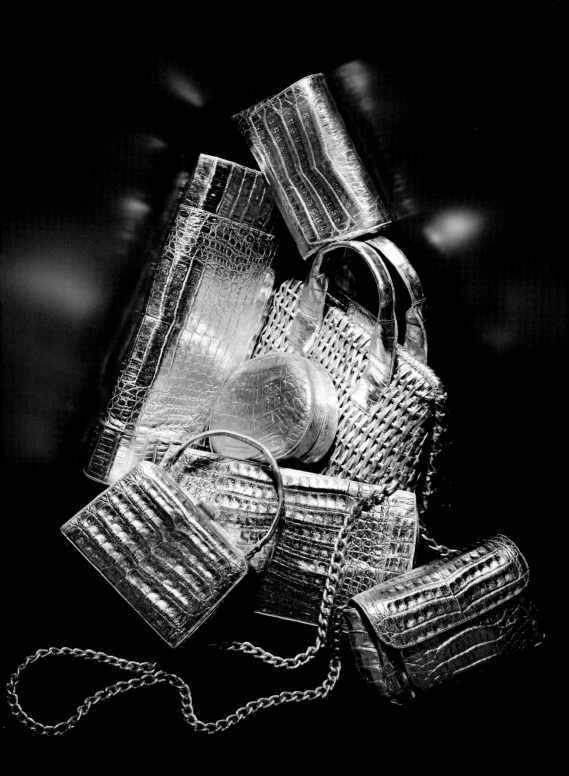

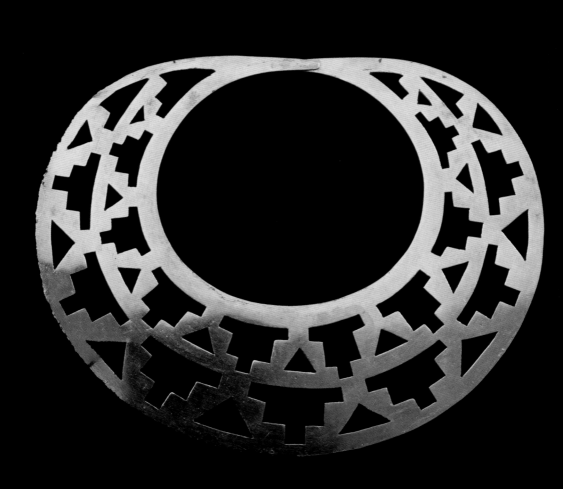

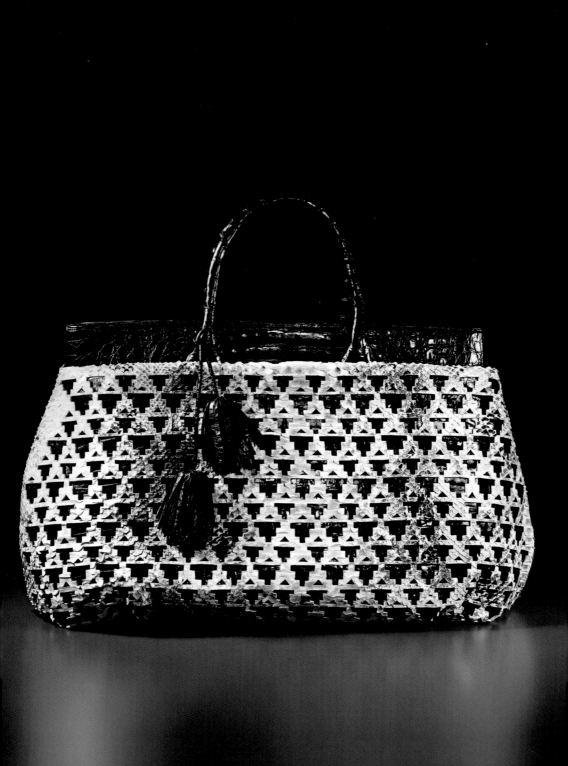

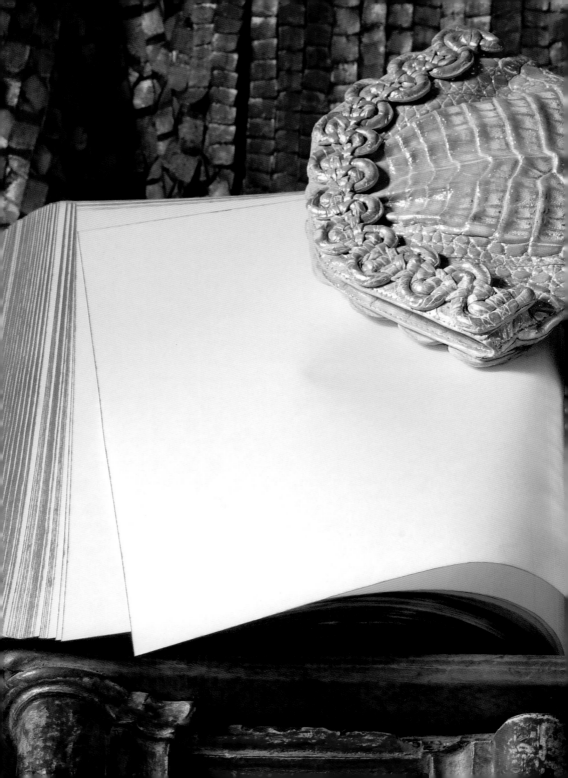

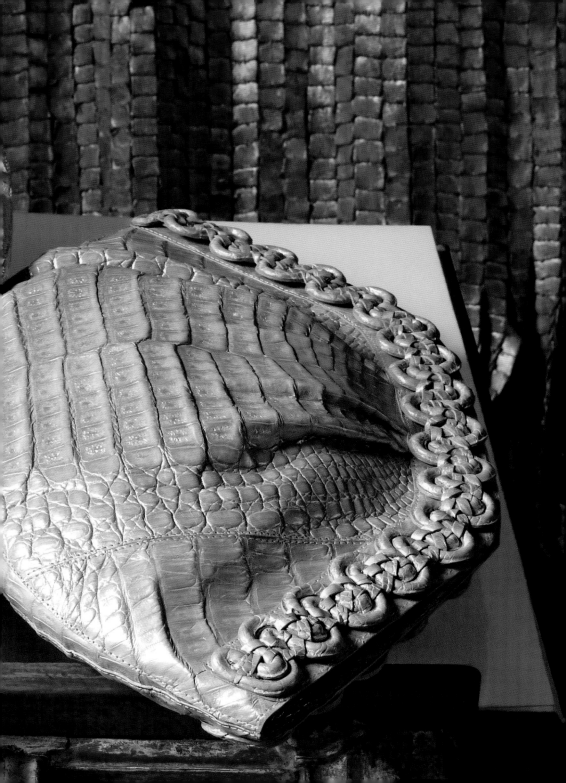

Purity:

I

The quality or state of being pure.

II

*Genuineness, realness,
naturalness, authenticity.*

III

Perfection.

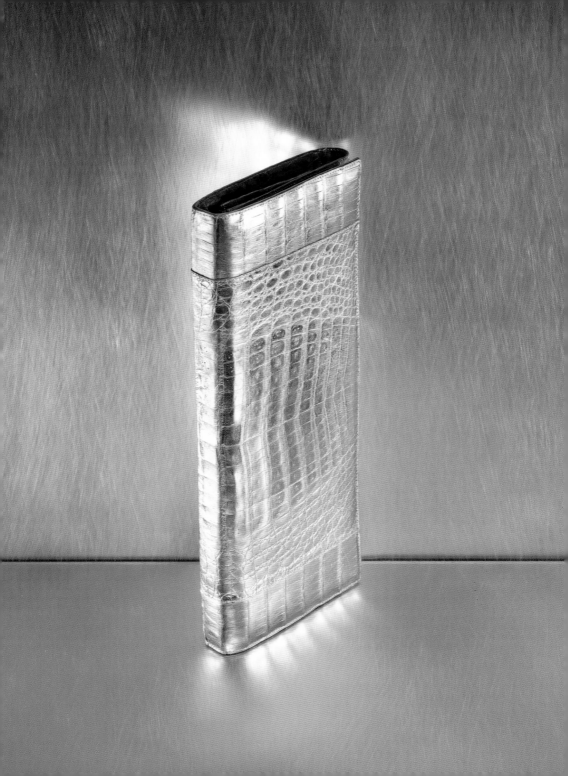

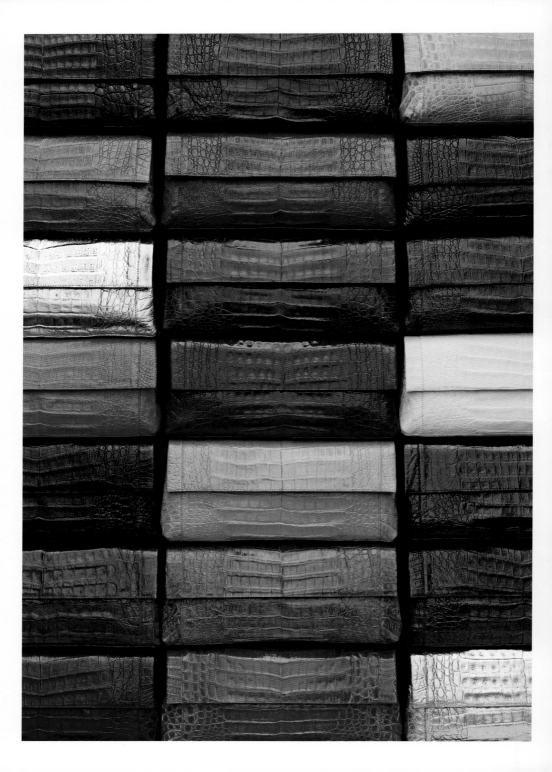

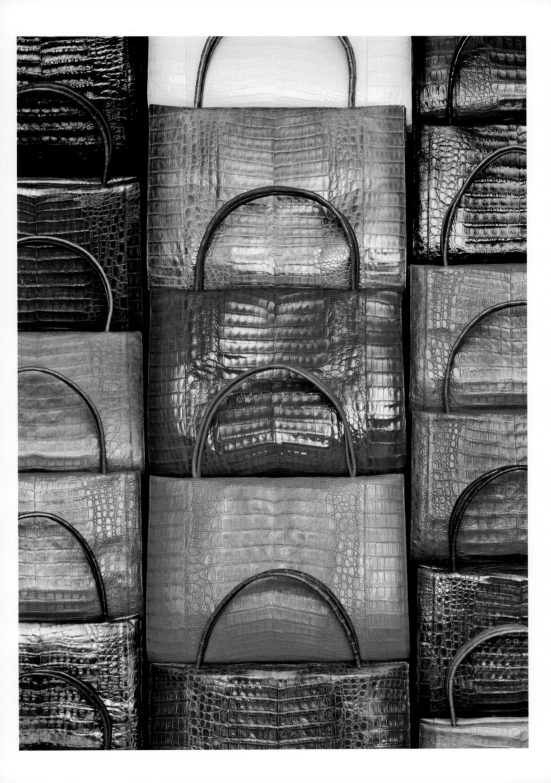

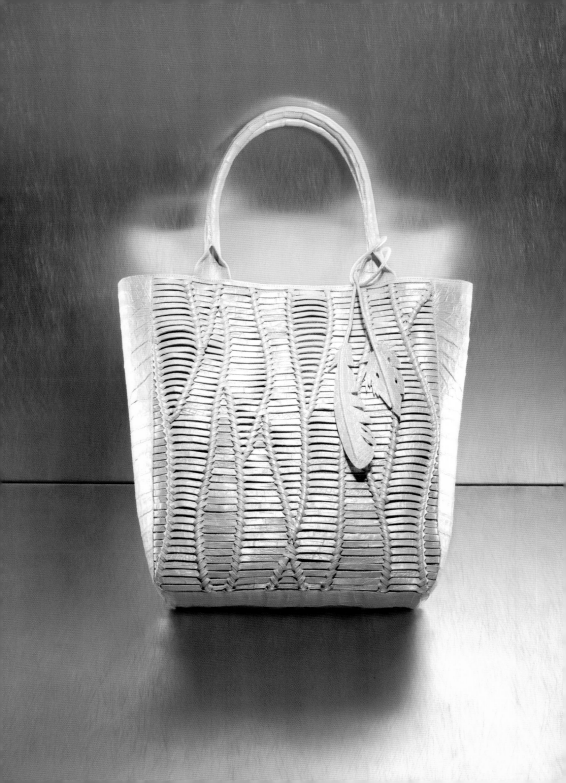

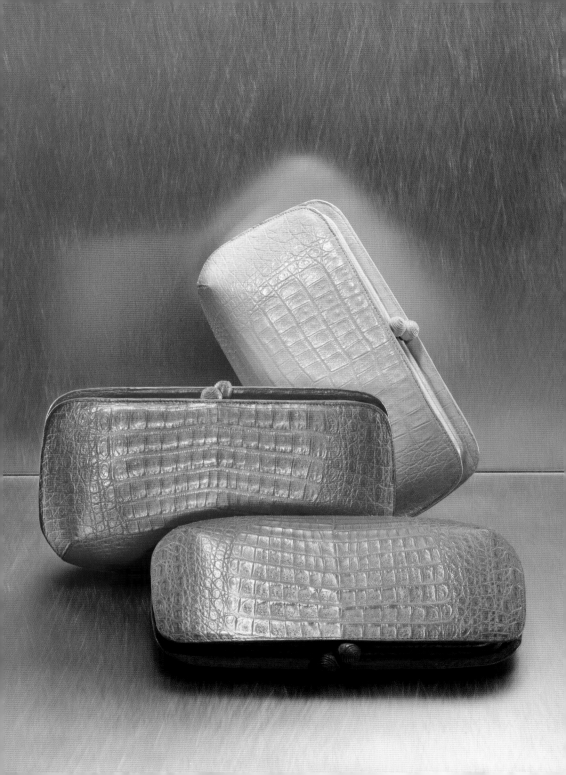

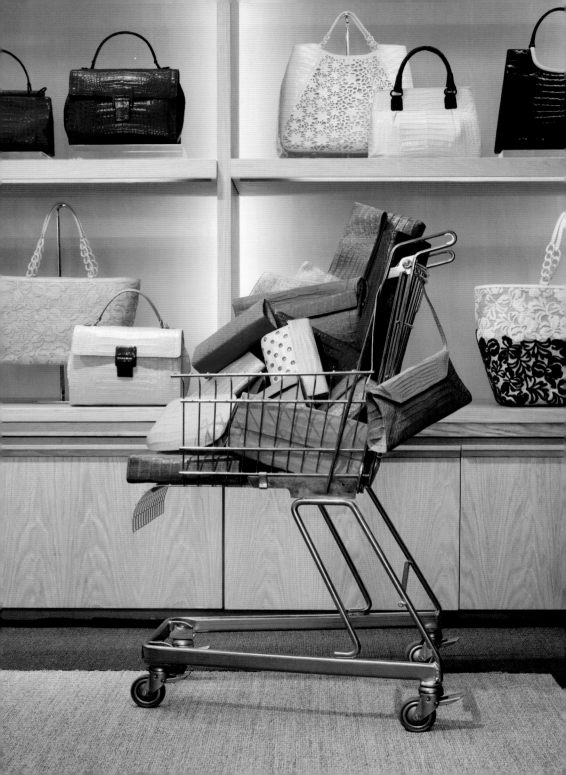

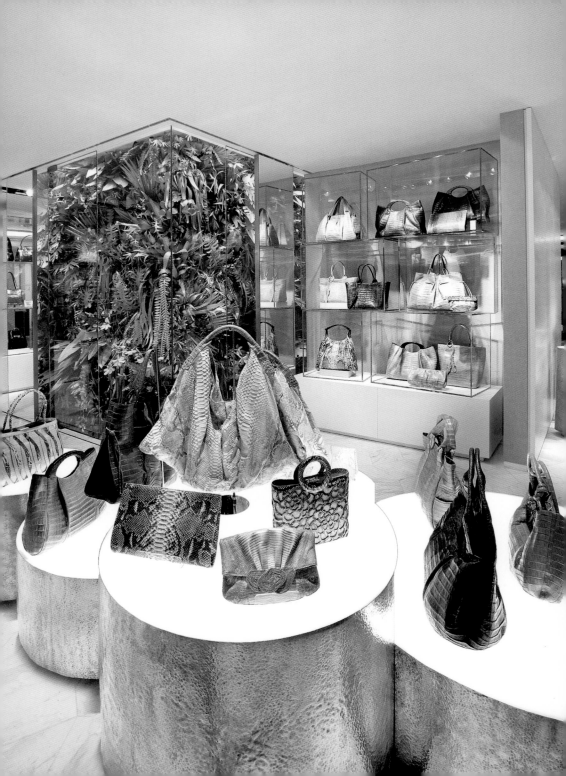

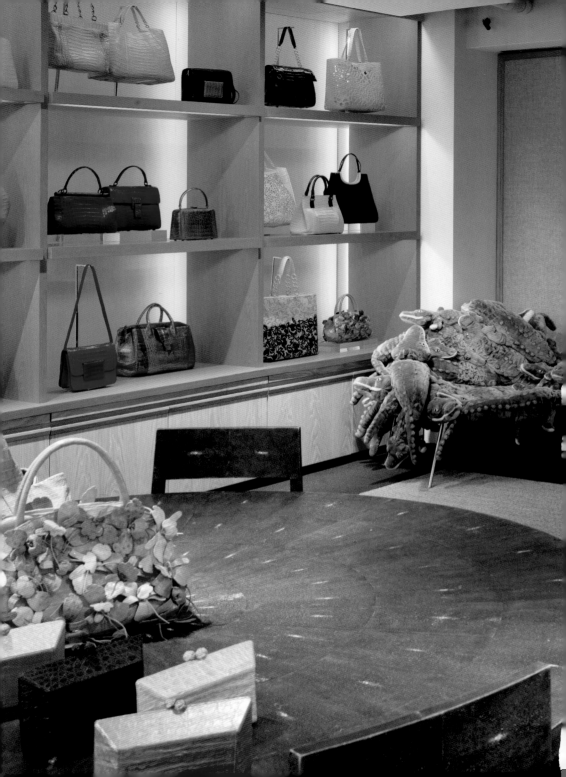

Authentic:

I

Not false or copied, genuine, real.

II

Having origins supported by unquestionable evidence, authenticated, verified, reliable, and trustworthy.

REGIONES ZOOGEOGRAFICAS

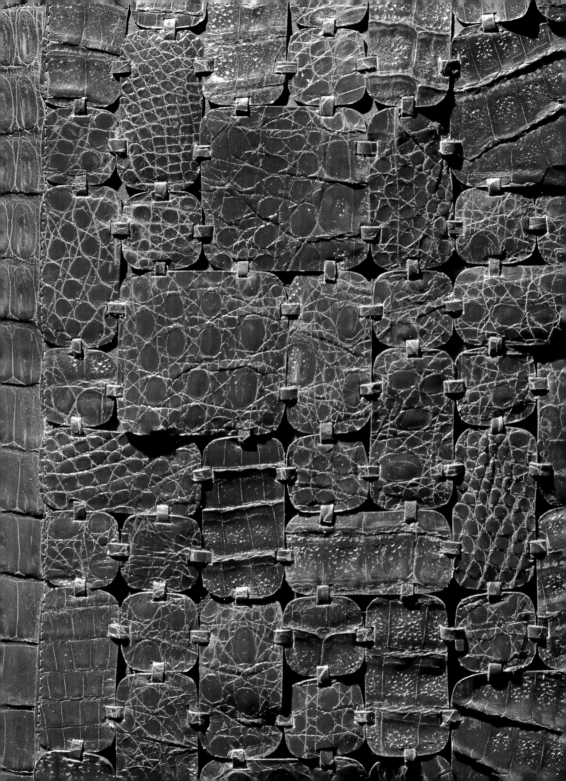

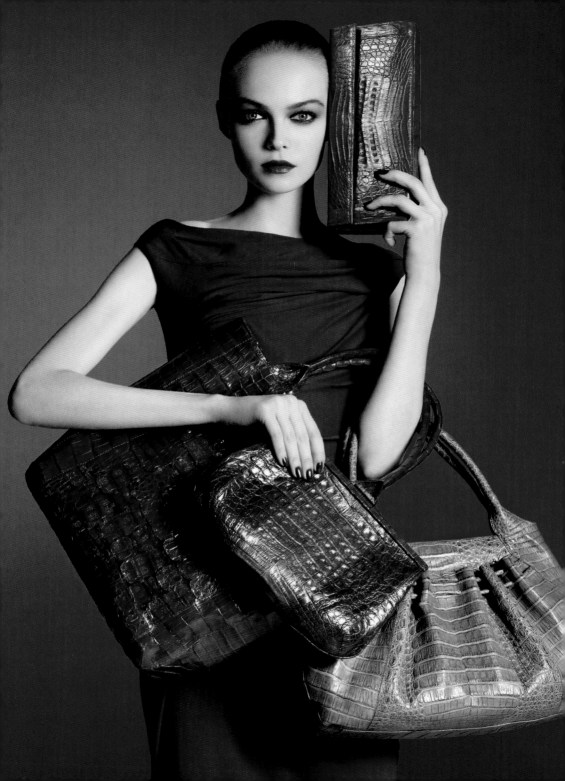

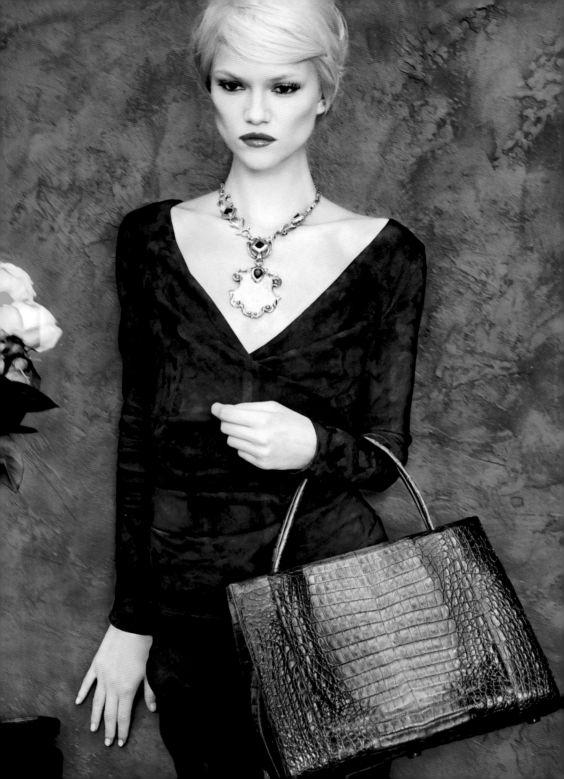

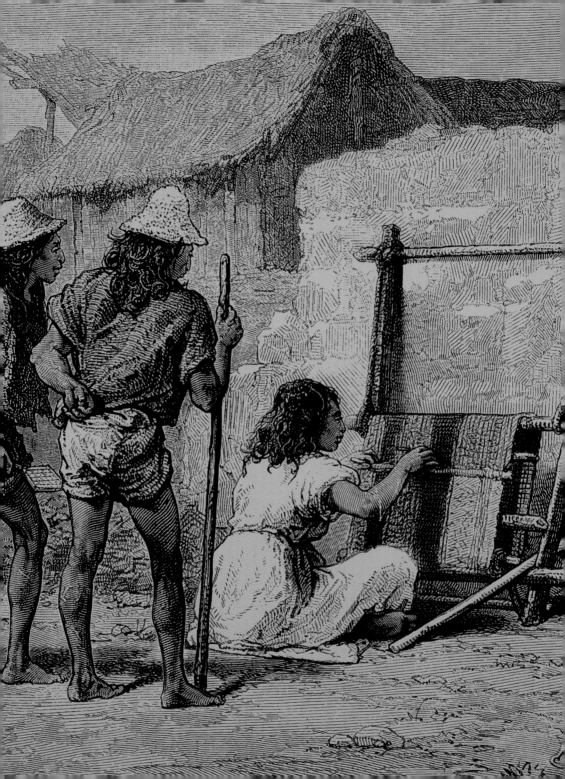

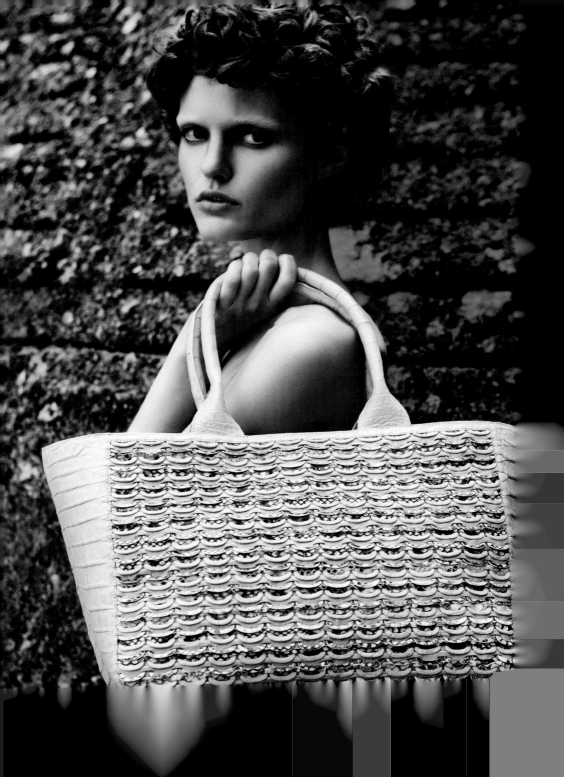

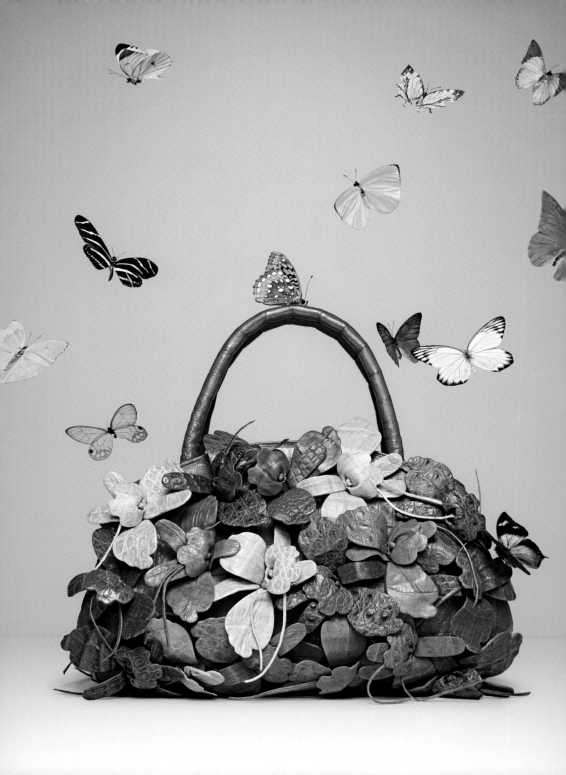

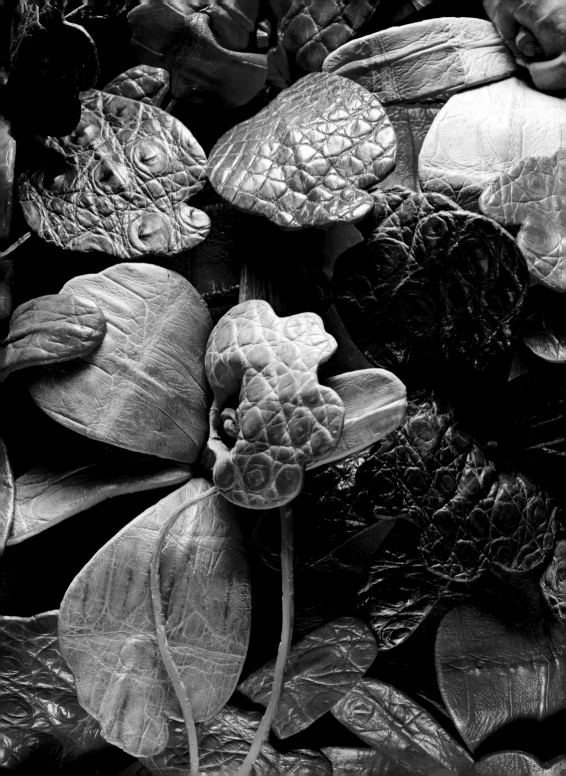

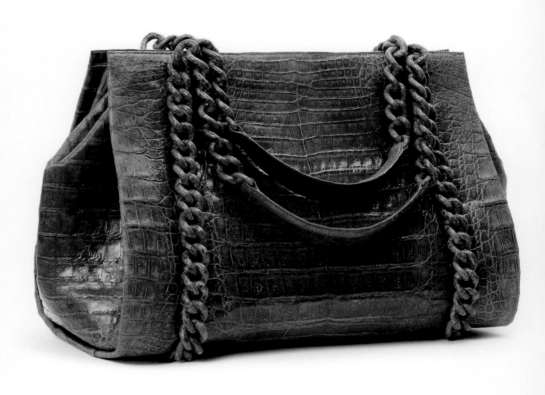

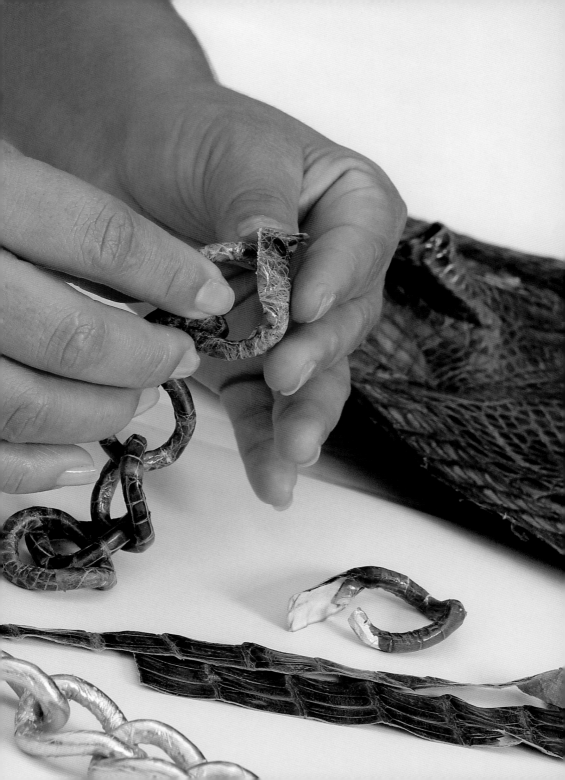

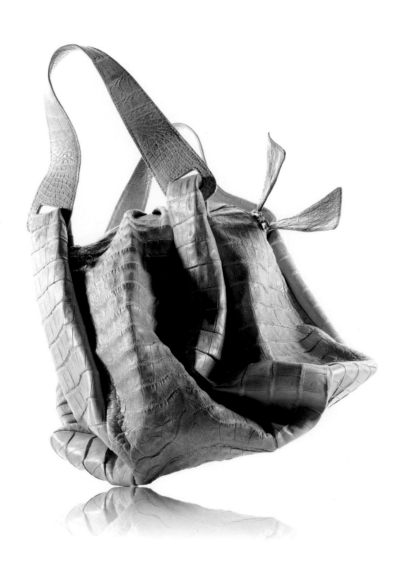

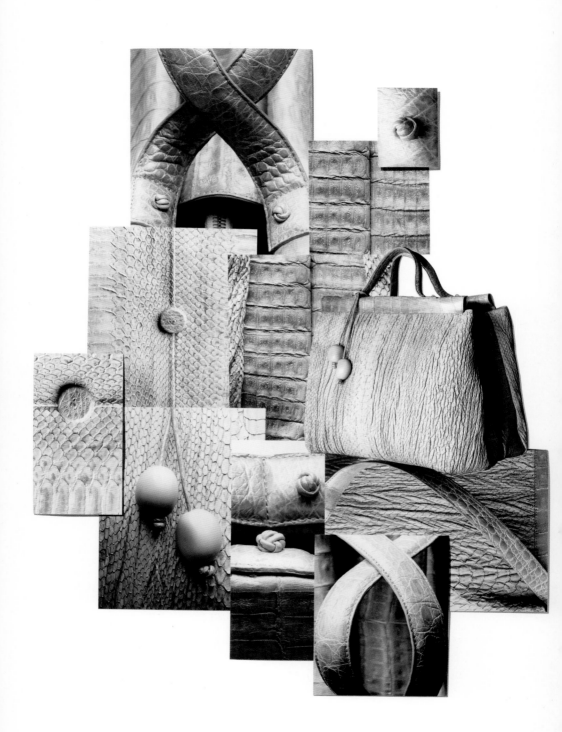

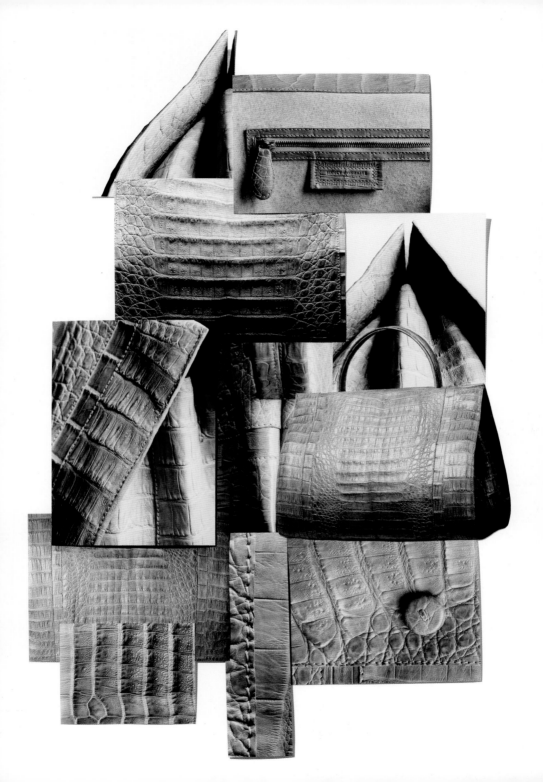

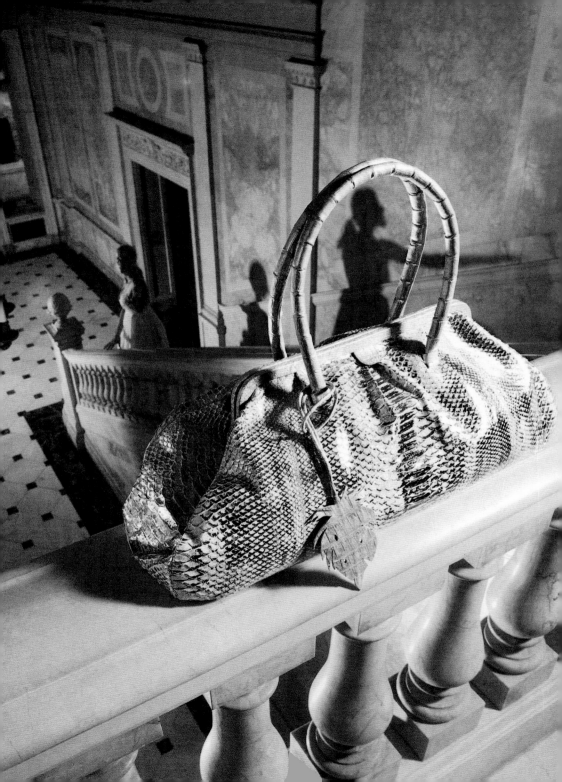

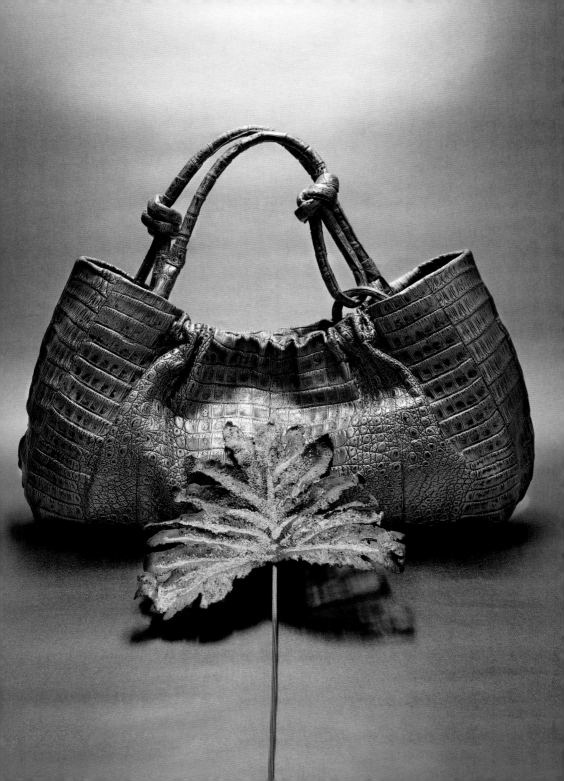

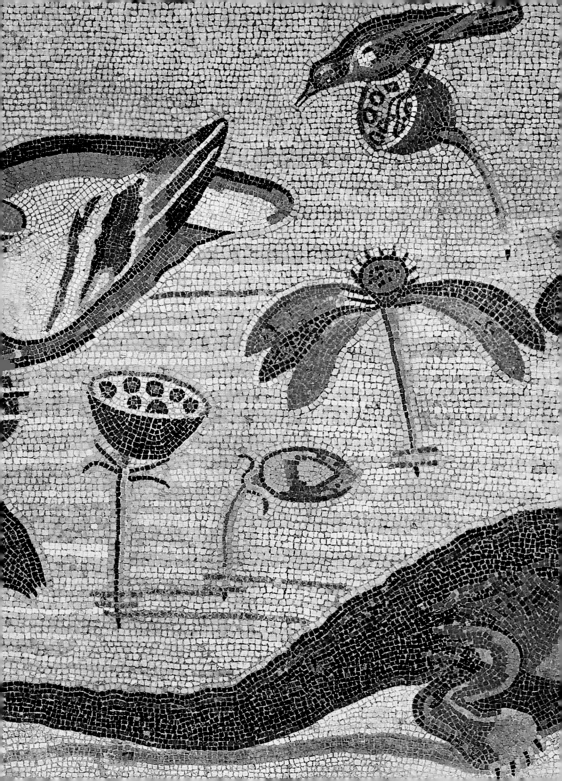

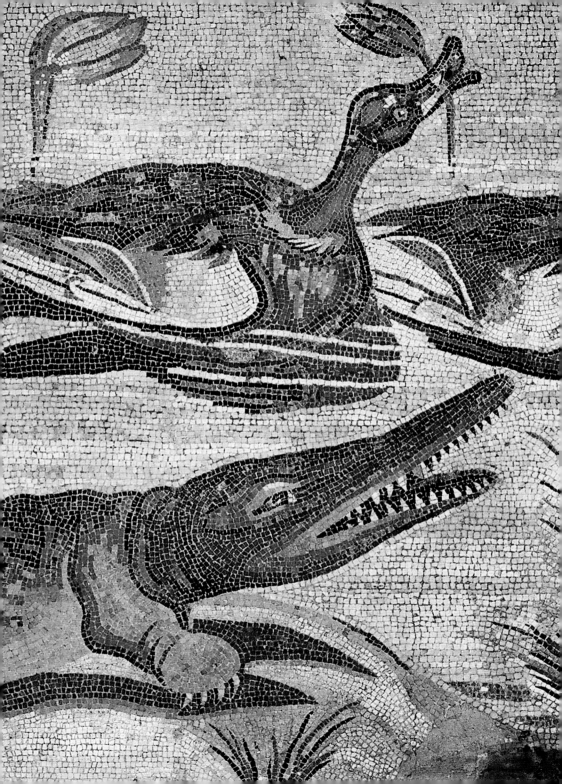

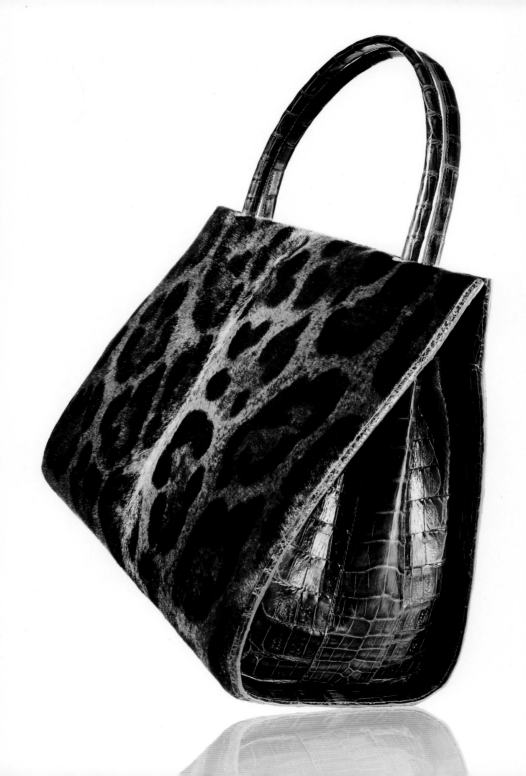

"Nature is my best collaborator, and life is my source of inspiration."

—Nancy Gonzalez

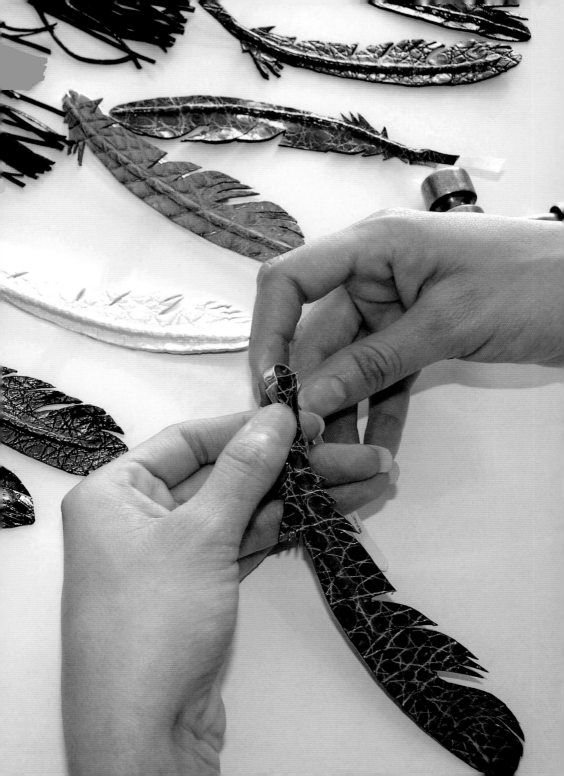

Tamaca Palms by Frederic Edwin Church, 1854. © The Corcoran Gallery of Art/Corbis.

Bergdorf Goodman window, Fall 2007. © Nancy Gonzalez.

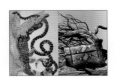

A Suriname caiman fighting a South American false coral snake (detail), by Maria Sibylla Merian, Suriname or Amsterdam, circa 1699–1705. Watercolor, 12 x 17.8 in. British Museum, London. © Trustees of the British Museum/Art Resource, NY.
Natural python fold-over bag, Spring 2005. Photographed by Kenji Toma for Bergdorf Goodman. © Kenji Toma/Trunk Archive.

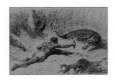

Antique etching of a crocodile hunt.

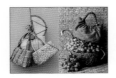

Clockwise from top: **Yellow crocodile half-moon clutch with woven detail, multicolored crocodile round top-handle tote, yellow crocodile crocheted tote with natural banana-leaf lining, and taupe and beige crocodile woven bag with tangerine banana-leaf lining**, 2004. © Gilles Bensimon/Trunk Archive.
Terra-cotta crocodile and linen hobo with crocodile ball handle, Resort 2008. © Anita Calero.

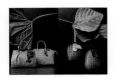

Ostrich cherry tote and ostrich pineapple bowler. © Anita Calero.
Hand-woven crocodile apple and pineapple bags. © Anita Calero.

Opposite: Artisan hands with crocodile banana leaf. © Nancy Gonzalez.

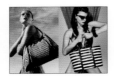

A-line hobo "degradé smoke" crocodile, Spring 2009. Photographed by Will Davidson for Bergdorf Goodman. © Will Davidson.
Shutter tote in navy crocodile and handwoven banana leaf fiber. Photographed by Sebastian Kim for Bergdorf Goodman. © Sebastian Kim.

Colorblock-stripe tote in taupe, prune, black, and gray crocodile, Fall/Winter 2011 advertising campaign. © Anita Calero.

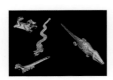

Top: **Mammal-shaped pendant with raised tail.** Chocó, circa 600–1600 A.D. 5.3 x 3.3 cm. *Center:* **Snake-shaped votive figure.** Cordillera Oriental, Muisca, circa 600–1600 A.D. 7.9 x 1.8 cm. *Bottom:* **Iguana-shaped pendant.** Middle Cauca Valley, Early Quimbaya, circa 500 B.C.–700 A.D. 15 x 2.7 cm. © Banco de la República, Gold Museum Collection, Bogotá, Colombia/Clark M. Rodríguez. **Lizard-shaped pendant.** Middle Cauca Valley, Early Quimbaya, circa 700–1600 A.D. 30 x 6 cm. © Banco de la República, Gold Museum Collection, Bogotá, Colombia/Clark M. Rodríguez.

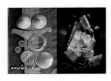

Pre-Columbian gold artifacts. Nancy Gonzalez collection. © Anita Calero.
A treasure trove of gold crocodile. © Anita Calero.

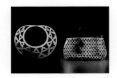

Crescent-shaped nose ornament. Nariño, late period, circa 600–1700 A.D. 13.2 x 15.9 cm. © Banco de la República, Gold Museum Collection, Bogotá, Colombia/Clark M. Rodríguez. Natural lasered python and crocodile bag inspired by crescent-shaped nose ornament. © Anita Calero.

Silver and pearlized-blue crocodile oyster clutches with wave appliqué, Resort 2008. © Anita Calero.

Gold bar clutch, Spring/Summer 2012 advertising campaign. © Anita Calero.

Clutch color repetition, Fall/Winter 2012 advertising campaign. © Anita Calero.
Frame bag color repetition, Fall/Winter 2012 advertising campaign. © Anita Calero.

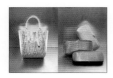

Woven leaf tote, Spring/Summer 2012 advertising campaign. © Anita Calero.
Kiss-lock minaudières, Spring/Summer 2012 advertising campaign. © Anita Calero.

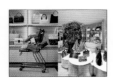

Nancy Gonzalez showroom, New York City, with crocodile clutches piled in Frank Schreiner's "Consumer's Rest" chair. © Anita Calero.
Nancy Gonzalez boutique, Galleria Department Store, Seoul, South Korea. © Nancy Gonzalez.

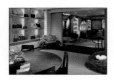

Nancy Gonzalez showroom, New York City. © Anita Calero.

Nancy Gonzalez showroom, New York City, with a display of rainbow crocodile clutches in Martino Gamper's Chair with Shelves. © Anita Calero.

Antique map of Colombia. © All rights reserved.
Detail of burgundy crocodile mosaic tote, Fall 2008. © Anita Calero.

Clockwise from top: **Cherry crocodile flap clutch, lavender crocodile shoulder bag with gathered pocket, "degradé purple" crocodile frame clutch, and burgundy crocodile mosaic tote.** Photographed by Terry Tsiolis for Neiman Marcus. © Terry Tsiolis.
Peacock "degradé blue" crocodile Wallis frame bag. © Erik Madigan Heck/Trunk Archive.

Antique etching of a Colombian Sibundoy Indian weaving at a loom. © All rights reserved.
Crocodile and python hand-woven tote in yellow. Photographed by Vanina Sorrenti for Bergdorf Goodman. © Vanina Sorrenti.

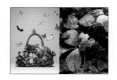

Handmade crocodile orchid bouquet bag (with detail at right). © Anita Calero.

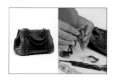

Green frame bag with crocodile-covered chain. © Nancy Gonzalez.
Chain being covered in crocodile skin. © Nancy Gonzalez.

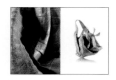

Draped aqua crocodile bowler bag (with detail at left), Resort 2009. © James T. Murray.

Gray pleated python and crocodile top-handle tote with knot detail, Spring/Summer 2010 advertising campaign. © Anita Calero.
Lavender Wallis frame bag, Spring/Summer 2010 advertising campaign. © Anita Calero.

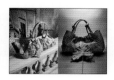

Crocodile and hand–gold leafed python frame shoulder bag with banana-leaf detail, Fall 2005. Photographed by Greg Delves for Neiman Marcus. © Greg Delves/Judy Casey.
Pewter crocodile knot hobo, Spring 2006. © Anita Calero.

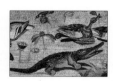

Aquatic animals from a Pompeii mosaic band, first century A.D., Museo Archeologico Nazionale (National Archaeological Museum), Naples, Italy. © Erich Lessing/Art Resource, NY.

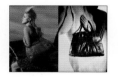

Hot pink crocodile contour tote with side ruched detail, Spring 2008. Photographed by Satoshi Saïkusa for Bergdorf Goodman. © Satoshi Saïkusa.
Bronze crocodile ruffle tote. Photographed by Greg Delves for Neiman Marcus. © Greg Delves/Judy Casey.

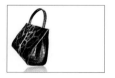

Wallis frame bag in peacock leopard-print calf-hair with crocodile trim. Photograph by Nigel Cox for Bergdorf Goodman. © Nigel Cox.

Acknowledgments

This book could never have been created without the tireless work of Pamela Golbin, Robin Marsicano, and especially Santiago Barberi Gonzalez—thank you. The publisher would also like to thank all the photographers taking part, particularly Gilles Bensimon, Anita Calero, Nigel Cox, Will Davidson, Greg Delves, Erik Madigan Heck, Sebastian Kim, James T. Murray, Satoshi Saïkusa, Vanina Sorrenti, Kenji Toma, and Terry Tsiolis. In addition, we are grateful to Allison Ballou, Aidan Kemp, and Victoria Stevens (Bergdorf Goodman); Malgosia Bela, Leigh Crystal, Beth Dubin, and Katie Fogarty (Next Model Management); Jennifer Belt (Art Resource, NY); Judy Casey (Judy Casey); Gary Dakin and Crystal Renn (Ford Models); Oscar Espaillat (Corbis); Sophie Fels; Chris Gay and Masha Novoselova (Marilyn Agency New York LLC); Lauren Kelly (Jed Root, Inc.); Justinian Kfoury (Total Management); Beverly Ann Moore and Kim Stanley (Neiman Marcus); Patrick O'Leary (Art Department); Timothy Priano and Daniela Marin (Artists by Timothy Priano); Clark M. Rodríguez B. and María Alicia Uribe Villegas (Gold Museum); Justin Stuart Rose (Trunk Archive); Erin Stella (Nigel Cox Inc.); Heather Strange (Wilson & Wenzel); Kasia Struss; Helena Suric and Siri Tollerod (DNA Model Management LLC); and Benjamín Villegas (Villegas Editores).